$20

LARRY SCHWARM

LARRY SCHWARM

Larry W. Schwarm
2018

KANSAS FARMERS

EDITED BY KATE MEYER

WITH A FOREWORD BY NANCY KASSEBAUM BAKER

 UNIVERSITY PRESS OF KANSAS

Published by the University Press of Kansas (Lawrence, Kansas 66045), which
was organized by the Kansas Board of Regents and is operated and funded by
Emporia State University, Fort Hays State University, Kansas State University,
Pittsburg State University, the University of Kansas, and Wichita State University.

Published in partnership with the Spencer Museum of Art, University of Kansas.

Library of Congress Cataloging-in-Publication Data

Names: Meyer, Kate, editor. | Schwarm, Larry, 1944– Photographs. Selections.
Title: Larry Schwarm : Kansas farmers / edited by Kate Meyer.
Description: Lawrence, Kansas : University Press of Kansas, [2018] | Catalog
 of an exhibition held at the Spencer Museum of Art, August 2018.
Identifiers: LCCN 2018012647 | ISBN 9780700626557 (cloth : alk. paper)
Subjects: LCSH: Landscape photography—Kansas—Exhibitions. |
 Farms—Kansas—Pictorial works—Exhibitions. | Water resources
 development—Research—Kansas—Exhibitions. | Kansas—Pictorial
 works—Exhibitions. | Schwarm, Larry, 1944—Exhibitions.
Classification: LCC TR647 .S39977 2018 | DDC 770.74/781423—dc23.
LC record available at https://lccn.loc.gov/2018012647.

British Library Cataloguing-in-Publication Data is available.

Printed in the United States of America

10 9 8 7 6 5 4 3 2 1

The paper used in this publication is recycled and contains 30 percent
postconsumer waste. It is acid free and meets the minimum requirements of
the American National Standard for Permanence of Paper for Printed Library
Materials Z39.48-1992.

Contents

Foreword

In his farewell address to the nation, the thirty-fourth president of the United States, Dwight D. Eisenhower from Abilene, Kansas, offered this advice:

> Crises there will continue to be. In meeting them, whether foreign or domestic, great or small, there is a recurring temptation to feel that some spectacular and costly action could become the miraculous solution to all current difficulties. . . .
>
> But each proposal must be weighed in the light of a broader consideration: The need to maintain balance in and among national programs . . . balance between the cost and hoped for advantages— balance between the clearly necessary and the comfortably desirable. . . . Good judgment seeks balance and progress; lack of it eventually finds imbalance and frustration.

I believe this is wise counsel for all situations and every era. The beautiful photography of *Larry Schwarm: Kansas Farmers* illustrates the importance of balance in the use of our Earth. Kansas farmers and ranchers are keenly aware of the seasons—when to reap and when to sow. The weekly weather forecast becomes the bellwether of our lives. Farmers and ranchers have come back from devastation, dust storms, and depression. There has always been a debate over how much or how little government should intervene. In 1932, one in four workers was unemployed, and wheat had gone from $1.00 to 61 cents a bushel, cotton from 16 cents to 6 cents. One million families lost their farms. In 1933, the Agricultural Adjustment Act aimed to reduce the surplus of products to help raise prices and paid farmers to take land out of production. The involvement of the federal government has moved a long way since then.

Our relationship with the land is important to the decisions that must be made regarding such considerations as terracing, irrigation, market prices, type of crop, and seed selection. As is often true, there are unintended consequences to those decisions. Water is a most important issue for farmers and ranchers. However, a solution to the dwindling groundwater aquifers has not yet been met.

While climate change is acknowledged and television has shown dramatic pictures of the gradual changes that are occurring, it is often still in the discussion or "cussed" stage. How will it directly affect me? *Larry Schwarm: Kansas Farmers* vividly captures the legacy of Kansas farmers and ranchers, their independent spirit, and their harmony with the land. It also raises our awareness of how much we all have at stake in looking to the future.

The backbone of Kansas farming and ranching is our communities. While many rural communities grow smaller each year, these communities still represent our heritage and are important in discussions to the challenges we face today. Now, as in the past, "good judgment seeks balance and progress"—and this is critical as we move forward in a changing world.

Nancy Kassebaum Baker
Former United States Senator

Preface: A New Partnership

Art initiates questions through expressive forms of inquiry. It opens possibilities and offers surprising new discoveries by uniting artistic process with other rigorous research methods. Larry Schwarm brings his experience as an accomplished artist living in Kansas to related explorations by social and natural scientists, as well as engineers, at the University of Kansas. His photography inspires attentive looking and personal investigations that contribute to understanding the mark a single person can make upon our environment through his or her decisions and actions.

This research question—a desire to understand the factors affecting decisions farmers make, as well as the impacts of those decisions on land and water use and quality—inspired scholars to work collaboratively across disciplines. A subject as nuanced and complex as human decisions and their impacts on the environment involves anthropological, ecological, economic, geographic, political, and social dimensions, to name but a few disciplines united in this pursuit. Though broadly interdisciplinary, the research project remained grounded in the social and natural sciences, as well as engineering, until our paths crossed.

During the 2009 holidays we met for the first time. It was a party, but all of us were talking about our work—our life work. The conversation was lively and intriguing, charged with that sense of excitement that comes with unexpected sparks among disciplines in contact. During the course of the evening, we decided to continue the conversation at an institutional level, to look for connections between this emerging research project exploring farmers' decisions and the art museum's focus on artistic research. Dedicated to assessing where the natural crossings occur, we began to meet with our collaborators at the University of Kansas, Wichita State University, and Kansas State University, seeking to find common ground as well as anticipating the thrill of differences. Most notably, our art museum and our research project partnered to commission artist Larry Schwarm to join the project, conduct artistic research, and produce hundreds of photographs for a series Schwarm has titled *Kansas Farmers.* Nearly a decade later, we are proud to share the way that an open conversation leads to intellectual utility, public awareness, and beauty. We have become academic partners as well as colleagues.

This partnership has produced the book you hold and a fall 2018 exhibition of these photographs at the Spencer Museum of Art. The book includes an essay from Dr. Dietrich Earnhart describing the many disciplinary lenses and tactics the research team employed to understand better farmers' decisions and their environmental impacts. It continues with an essay from Dr. Kate Meyer exploring the impact of adding the artist Larry Schwarm to the project. *Larry Schwarm: Kansas Farmers* concludes with fifty of Schwarm's photographs paired with texts revealing the many ways individuals with different kinds of expertise "see" each photograph.

This book reflects our commitment to the strength of disciplinary mastery and the integrative potential of transdisciplinary work. Above all, it captures our university's aspiration to make and share discoveries that change the world. At the heart of the project is Dr. Kate Meyer, whose commitment to place is manifest in every detail. Her scholarship is only

rivaled by her abiding love of Kansas and its people. On behalf of the Spencer Museum and the KU Center for Environmental Policy, which led the Farmers' Land Use Decisions research project, we offer our grateful thanks to Dr. Meyer and to Larry Schwarm whose images are at once memorable and arresting, yet reaffirming.

Saralyn Reece Hardy
Marilyn Stokstad Director, Spencer Museum of Art

Dietrich Earnhart
Director, Center for Environmental Policy; Principal Investigator, Biofuels and Climate Change: Farmers' Land Use Decisions Project

Research on Kansas Farmers' Land and Water Use Decisions

Dietrich Earnhart

Farmers make crucial decisions about land use such as crop choice, use of seed varieties, and conservation-management practices. Farmers also make important decisions about water use, including installing irrigation systems, pumping water from aquifers, and diverting surface water from streams, rivers, lakes, and reservoirs. These decisions, which have the potential to deplete aquifers and divert surface water away from in-stream uses, substantially affect the natural environment and influence the habitats needed to support both terrestrial and aquatic life. Additionally, climate change represents the defining global concern of the twenty-first century, and in many regards, agriculture is the economic sector most vulnerable to climate change because it critically depends on weather. Thus, climate change can potentially influence farmers' land and water use decisions.

As part of its Established Program to Stimulate Competitive Research in the state of Kansas, beginning in 2009 the National Science Foundation awarded a five-year grant to researchers at Kansas universities to study climate change and renewable energy. This award included subprojects concerning the science of renewable energy, the impacts of climate change and biofuel technology, the potential for mitigating the effects of a changing climate, and the development of educational pathways concerning climate-change research among Native American communities. To study impacts of climate change and biofuels on farmers and farmland, researchers at the University of Kansas, Kansas State University, and Wichita State University formed an interdisciplinary team to explore farmers' land and water use decisions. We called our research project "Biofuels and Climate Change: Farmers' Land Use Decisions." Our team represented the efforts of researchers from the visual arts, anthropology, environmental planning, economics, atmospheric science, sociology, geography, political science, and environmental engineering.

Our study examined farmers' decisions in the context of changing climate conditions and the dwindling availability of water, along with emerging biofuel-market opportunities, which have implications for the availability of groundwater and the quality of surface water. As its primary contribution, our interdisciplinary team developed a rich, deep database on land use, water use, climate and weather, water availability, surface-water quality, and biofuel markets over many years. Our team developed a unified set of qualitative and quantitative cross-disciplinary empirical methods for identifying the driving factors behind farmers' land and water use decisions. Moreover, our team developed a set of process-based modules involving the atmosphere, aquifers, and surface-water quality. Our team integrated visual imagery in order to explore farming decisions, especially farmers' land and water use decisions, in the context of changing climate conditions and diminishing groundwater availability. As the photographer associated with our research project, Larry Schwarm produced thousands of photographs, which were also

added to the database. Our primary research examines the period between 2000 and 2012, while our analysis of visual imagery focuses on the period between 2010 and 2013.

This essay describes the efforts of our research team to examine these issues using an integrated set of perspectives, data, and analytical methods. The rest of the book emphasizes our analysis of visual imagery, which represents a rich qualitative data set. These data provide an engaging dimension through which to understand the realities of and the decisions made by Kansas farmers.

Research Objectives, Frameworks, and Methods

Our research team had four objectives. First, we worked to identify the driving factors behind farmers' land and water use decisions. We focused on climate conditions, weather conditions, and availability of groundwater and surface water, making a strong distinction between physical and legal constraints. Although eastern, wetter states base a legal right to water on the presence of that water on a landowner's property, Kansas and other more arid western states adhere to a prior appropriation doctrine. In Kansas, prior to 1945, the earliest claim of water entitles right of use, irrespective of land ownership. In 1945, Kansas established a system for appropriating water rights, which is arguably the most sophisticated system in the world. Second, we modeled the key physical and natural environmental systems that are linked to agriculture in Kansas: future climate conditions in Kansas through the year 2100, sections of the High Plains Aquifer underlying Kansas for decades into the future, and surface-water quality conditions for the Kansas River system and other key river systems across the state into the next decade. Our third objective was processing satellite remote-sensing data in order to classify land use and land cover and irrigation status at the field level for the entire sample period between 2000 and 2012. The fourth and final objective involved integrating all of our efforts. We integrated a variety of data sets to develop a rich, multilayered database on land and water use decisions with human and environmental dimensions. We also developed a set of cross-disciplinary,

qualitative, and quantitative empirical methods for identifying the driving factors behind farmers' land use decisions.

Our team used two integrated frameworks. Our conceptual framework identifies the factors affecting farmers' decisions. Our empirical framework examines the decisions made by farmers, measured as observed or hypothetical behavior. When articulating our conceptual framework, we assume that farmers make choices guided by an objective that depends on multiple parameters that are constrained by various external factors beyond their control. In the most basic framework, an individual farmer chooses his/her land use and water use in order to maximize his/her personal welfare constrained by external factors, such as crop prices, input prices, climate conditions, and water availability. We extended this basic framework by incorporating social parameters into the individual farmer's objectives and social factors into the set of constraints. The conceptual perspective of the visual arts complements this social-scientific perspective by providing insight into the aesthetic dimensions of farmers' land and water use. How the land and water are seen, and thus understood, by farmers becomes as important as, if not more important than, how they are in reality. These aesthetic dimensions must influence the farmers' decisions.

In contrast to decision-makers, the environmental systems generate outcomes that are driven by both environmental factors and human decisions. For example, the nutrient loadings from an individual field to a surface-water body depend on both precipitation and the farmer's choice of land use. Accordingly, our integrated framework incorporated three environmental systems—atmosphere, aquifer, and ambient water quality—and interconnects these three systems with the human system directly or indirectly. Atmospheric conditions depend on land use and water use. The aquifer's conditions depend on precipitation and water use. The surface-water body's ambient quality depends on precipitation, land use, and water use.

These atmospheric conditions and the physical availability of groundwater from aquifers constrain land and water use decisions. Our team

primarily explored the effects of these constraints on *decisions*, and then assessed the influence of atmospheric conditions and groundwater availability on human-related *outcomes*. Our framework connects weather conditions to crop-yield outcomes and agricultural-profit outcomes. Both of these outcomes are human-related because farmers possess many ways of adjusting their practices, in light of atmospheric and groundwater conditions, in order to increase their yields and lower costs so that profits are higher.

Our integrated conceptual framework guided the construction of our integrated empirical framework so that the two frameworks are parallel. Our empirical framework included the parameters driving each farmer's objective as well as every constraint factor identified in our conceptual framework. Each conceptual element has its empirical counterpart. In the end, our empirical analysis links the objective parameters and the external constraints to observed land and water use decisions, utilizing empirical data. We linked this scientific framework with the complementary perspective of the visual arts, which guided the empirical analysis of the aesthetic dimensions identified in the conceptual framework. We captured these dimensions using Schwarm's photographs of farmers, farms, the land, and water.

Our team used a complementary set of qualitative and quantitative empirical methods based on our extended empirical framework to establish links between the conceptually identified factors and observed land and water use choices. Together these methods yielded much greater confidence in empirical results than either method employed alone. The conclusions drawn from the results of the qualitative analysis helped validate and interpret the quantitative empirical results. The empirical results of the quantitative analysis shaped the structure of our qualitative analysis.

Data

To identify the driving factors in the empirical analysis of the farmers' land use and water use decisions, our team gathered and generated data on three broad levels: field, farm, and county. The farm-level data are qualitative and quantitative, further separated into information on actual and hypothetical land use decisions. As much as possible, our team gathered information in multiple years, including surveying farmers multiple times between 2011 and 2013. Exploration of these multiyear data generates more accurate empirical results because the presence of multiple observations for a single location allows the analysis to control for otherwise unobservable differences across fields, farms, and counties, or idiosyncrasies of individual locations. In the process, the analysis is better able to isolate the effects of key environmental and policy factors.

Our team drew upon eight primary data sources. First, we scrutinized available satellite remote-sensing data on land use and land cover at the 250-meter-resolution level. Using sophisticated routines, our team processed this data to classify land use, land cover, and irrigation status at the field level for each year in the sample period. Then the team created a crop, crop-rotation, and land-cover map for the entire state of Kansas. Second, we purchased proprietary field-level data on crops planted (measured in acres) on an annual basis between 2000 and 2010. As a critical feature, these field-level data are linked to the individual farmer operating each field. This link is extremely helpful because other data components provide a wide variety of information on individual farmers. These data provide information on the twenty-three thousand Kansas farmers who generated at least $10,000 in agriculturally related revenues and operated at least fifty acres in 2010. These restrictions allowed our team to maximize its coverage of the state's agricultural land in the most cost-effective fashion.

Third, our team administered a survey to farmers from across Kansas in two waves, implemented in 2011 and 2013. When selecting the sample for the initial wave of the survey, our team drew a random sample of ten thousand from the set of twenty-three thousand farmers identified in the proprietary data set. We stratified the sample on US Department of Agriculture (USDA) resource regions, which are defined by climate and soil conditions that reflect the region's capacity to grow individual crops.

This stratification ensured that we contacted farmers uniformly across these regions. Our administration of the first wave generated a 25 percent response rate. We administered the second wave by recontacting respondents of the first wave and contacting a new random set of farmers who appeared to irrigate their crops based on the proprietary data. Both sets of respondents were sent an extended survey that focused on water use decisions. The pair of survey waves provides data on land use and water use decisions, along with a wealth of information on farm and farmer characteristics.

Fourth, our team employed in-depth, structured interviews to gather information from a subset of the farmers surveyed in the first wave of 2010. As part of the first wave, our team asked respondents to provide their contact information if they were willing to be contacted with follow-up questions. Of the 512 respondents who provided their contact information, the team interviewed a random sample of 149 farmers. These in-depth interviews represent the best method for delving into the fine-grained details that influence farmers' land and water use decisions at the field level, especially the influences of social networks, farmers' histories, and farmers' expectations over future developments in the markets for biofuel crops.

Fifth, our team gathered and processed data from federal government databases. From these we incorporated county-level data on crop prices, acres planted by crop, federal agricultural-program payments, and economic details. Other databases provide information on soils, water-surface flows, terrain dimensions, and transportation networks—all of which we added to our database. Sixth, our team gathered data from state government databases. We gathered data on the physical availability of groundwater and the use of both groundwater and surface water by farmers from two databases maintained by the Division of Water Resources within the Kansas Department of Agriculture. The Kansas Department of Health and Environment (KDHE) provides data on ambient surface-water-quality conditions and pollutant loadings from point sources of wastewater discharges—for example, municipal wastewater treatment

facilities. Seventh, our team gathered data on a basic set of daily and monthly weather conditions: minimum temperature, maximum temperature, and precipitation. Eighth, our team generated thousands of original photographic images of farms and farmers across the state during the years 2011 to 2013.

We merged these data into three integrated data sets to build our deep, multiyear database. Each data set was configured to explore decisions and outcomes at one of three spatial scales: field, farm, and county. The database integrates information on land cover, land use, farmer and farm characteristics, farmers' annual water use, surface-water quality, groundwater availability, weather, and more elements in order to facilitate a rich depiction and understanding of land use and water use decisions and their impacts on groundwater availability and surface-water quality.

To supplement this information on farmers' actual decisions, our team generated data on hypothetical land and water use decisions, interpreted broadly enough to include an array of management practices. To generate these hypothetical decisions, we gathered hundreds of farmers in twelve locations across the state between December 2013 and February 2014. At these gatherings, we conducted stated-choice experiments by posing hypothetical scenarios relating to future climate conditions. For simplicity, we focused on aridity, which captures both temperature and precipitation conditions, and directly affects soil moisture, which strongly influences crop growth. We constructed the stated-choice experiments or scenarios to prompt the participating farmers to consider three climate conditions: normal aridity, greater aridity (more dry), and lesser aridity (more wet). Under each scenario, we asked farmers to identify their land and water management choices, such as crop choice, extent of irrigation, use of drought-tolerant seed varieties, and use of conservation-management practices.

Analysis

Using our integrated data sets and qualitative and quantitative methods, we analyzed field-level and farm-level decisions on land use in Kansas. In

general, the qualitative methods focus on the in-depth interviews of individual farmers. The team first coded the interview data and then searched for patterns among the codes in order to discern links between factors and decisions. In contrast, the quantitative methods focused primarily on the survey data. We employed statistical methods to estimate the links between factors (for example, weather conditions) and individual farmers' land and water use decisions.

To complement our analysis of field-level and farm-level land use decisions, our team also examined land use and water use at the county scale. In particular, our team employed quantitative methods to link economic, sociological, and environmental factors (for example, weather conditions) to land and water use as reflected in aggregate measures (for example, total amount of water used for irrigation by all farmers operating in a single county). In addition to studying actual decisions, our team empirically examined the hypothetical land and water use decisions described above. This analysis allows us to assess farmers' decisions under climate conditions that do not yet exist. To complement this social-scientific empirical analysis of farmers' land and water use decisions, our team employed visual analysis, which explores thousands of visual images in order to discern the relationships linking the imagery of farming to farmers' decisions regarding the land and water.

Products

Our interdisciplinary team produced a database integrating a vast array of human and environmental factors, developed and implemented

methods for identifying the factors driving farmer decisions, and created modules to explore the physical processes of the climate, aquifers, and watersheds. Our analysis of the integrated database generates noteworthy results. These results reveal that farmers constrained their water use when offered assistance from the state of Kansas under the Water Transition Assistance Program (WTAP). However, farmers only constrained their groundwater use and not their surface-water use. Our results also demonstrate that farmers reduced their water use in response to the creation of an Intensive Groundwater Use Control Area (IGUCA). Contrary to expectations, farmers adjusted their water use mostly by reducing their irrigated acreage and, to a lesser extent, lowering their intensive use of water per acre. In addition, our results show that farmers intend to adjust substantially both their field management, such as conservation practices, and financial management, such as crop insurance, in response to changing future climate conditions. Moreover, our results reveal that farmers meaningfully intensified their cropping rotations towards corn cultivation if located close to biofuel processing plants.

Our analytical results help policymakers. Using our results, the Kansas Department of Agriculture's Division of Water Rights is better able to manage the depletion of aquifers underlying the state. Similarly, our results help inform the efforts of the US Department of Agriculture at improving farmers' adaptation to climate change.

Cultivating *Kansas Farmers*

Kate Meyer

Agriculture seems like an old-fashioned, technical term for the work that farmers do. Despite stereotypical familiarity with farmers and farming, most Americans no longer know how to harvest a crop or trace their meals back to the soil. Farming claims the majority use of the Kansas landscape, yet farmers represent a small percentage of the population. Water use decisions impact dwindling groundwater aquifers such as the High Plains/Ogallala Aquifer. Land use decisions impact landscapes that mean more than food. They represent society's connection to homes, communities, and the past. "Agriculture," that technical term for farming, in fact means the science, art, or practice of cultivating the soil, producing crops, and raising livestock. By acknowledging agriculture as an inherently interdisciplinary pursuit, this essay explores the perhaps unexpected benefits found in uniting the arts and sciences to better understand the practice of farming. It outlines the ways in which a body of photographic work by Larry Schwarm concerning farming was cultivated and the ways these photographs contribute to a broader understanding of Kansas farmers' land use and water use decisions. Finally, the essay considers the photographs themselves and outlines the rationale behind the way they are presented in this book.

Project leaders from a National Science Foundation–funded research project called "Biofuels and Climate Change: Farmers' Land Use Decisions," along with leadership from the Spencer Museum of Art, explored commissioning an artist to be part of their interdisciplinary research team. After preliminary conversations, the Spencer Museum investigated prospective artists and proposed a commission to Kansas-based artist and photographer Larry Schwarm. Schwarm responded with enthusiasm and with questions regarding the scope of the project and expectations for his contributions. His initial goal was to address the topic of Kansas farmers photographically by casting a wide net geographically and by capturing farming at many scales, from family farms to mega-farms. In August of 2011, Schwarm shared his photographs with members of the team

Figure 1. Reception for Biofuels and Climate Change: Farmers' Land Use Decisions Research Symposium in Spencer Museum of Art's Print Study Room, 2011. Image by Ryan Waggoner, copyright by the Spencer Museum of Art, The University of Kansas.

Figure 2. Detail of the exhibition Visualizing Farmers' Land Use Decisions, *2012. Image by Ryan Waggoner, copyright by Spencer Museum of Art, The University of Kansas.*

(fig. 1), meeting many for the first time. After more conversations, Schwarm articulated his own more nuanced research plan and questions. He would reveal the faces of the kinds of farmers whose land use decisions were being studied. He would capture the ways those decisions were and are made. He would interrogate the conditions under which agriculture in Kansas is occurring. These avenues of investigation would come to diversify the potential of Schwarm's own evolving research, but also ways in which the project's research could be understood and then communicated to audiences.

From July 31 to September 2, 2012, the Spencer's Teaching Gallery served as a home for *Visualizing Farmers' Land Use Decisions,* an installation of data drawn from the research project (fig. 2). The project's research included an impressive array of data collection and analysis related to agriculture in Kansas, including surveys and interviews of farmers, environmental factors, and economic factors impacting land use decisions, and the use of spatial remote sensing technology to study land use and land cover. The numerous forms of data gathered by the research team were visualized by printing interview transcriptions as texts, rendering survey results as charts and graphs, outputting remote-sensing data, and sharing Schwarm's photographs. In this installation, the team's research and observations emphasizing the theme of water—which itself suggested such broad topics as precipitation, irrigation, flooding, drought,

and crop growth and yield—were presented in a visual form. The installation showcased the necessity of interdisciplinary research when addressing complex questions related to human interactions with the environment, the diverse results such inquiries yield, and the significant role visual communication plays in rendering research meaningful and impactful to a viewer.

This exhibition was intended more as an installation piece and a visual experiment than a conclusive product. Each observation, though aligned toward the theme of water, consciously lacked contextualization or synthesis. To understand the content, deliberately conceived as a barrage of visual information, a viewer needed to absorb the images, visualizations, and texts and then create connections among them. Viewers with expertise in one or more of the same disciplines as members of the research team fared better, as they could approach that content confidently, be it quantitative data, qualitative data, scientific modeling, or art. Rarely could a single viewer fully comprehend every form and piece of content without receiving context or translation from an expert who was rarely present in the installation. At a museum reception, members of the research team and project stakeholders were able to explore their shared interests while engaging with the exhibition. The installation functioned as something of a Rosetta Stone, encouraging viewers to translate the various visualized languages of communication without providing a key in the form of synthesis or narrative.

As the research project progressed to its fourth year, the Spencer's exploration of the emerging narratives uniting the research took a more cohesive and coherent form. From August 3 to December 15, 2013, the museum exhibited *1 Kansas Farmer,* an installation of six large posters designed by students at the University of Kansas (fig. 3). For the 2013–2014 academic year, the university selected Timothy Egan's *The Worst Hard Time,* a book about the Dust Bowl of the 1930s, as a Common Book that would be part of shared curriculum for first-year students. The installation *1 Kansas Farmer* drew inspiration from the art, science, and history of the Dust Bowl and turned to those disciplines for a better

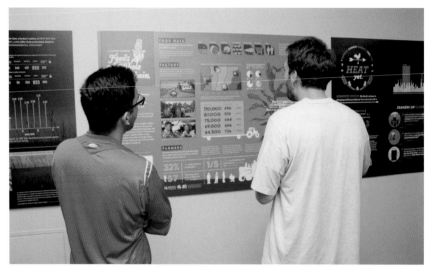

Figure 3. Detail of the exhibition 1 Kansas Farmer, *2013. Image by Ryan Waggoner, copyright by Spencer Museum of Art, The University of Kansas.*

understanding of the realities facing Kansas today. The Spencer collaborated with a KU advanced graphic design class, and as an assignment and service-learning opportunity, these students created a poster series that visually communicated the research of the project. To design the panels, twenty-four graphic design students engaged with Larry Schwarm's photographs and artworks from the Spencer Museum of Art and Kansas State University's Beach Museum of Art, as well as interview quotations, survey responses, and other materials collected by the research team.

The students were tasked with creating narrative posters and utilized a magazine-design strategy that invited the viewer to browse. Each poster consisted of a theme and a headline referencing ubiquitous Kansas billboards stating how many people are fed by the work of a single Kansas farmer. The students' graphic representations of research, statistics, quotations, and photographs documenting potential environmental disasters facing Kansas today were inspired by the powerful documentation of the Dust Bowl, much of which has survived as art that both transcends and fulfills its documentary purpose. Each poster was required to include a

headline, narrative commentary, artwork, quotations from farmers, and quantitative data in the form of survey-response percentages and other statistics. The six posters investigated the Dust Bowl, whether the Dust Bowl could recur, Kansas farmers today, stewardship, biofuels, and climate change.

Through these exhibitions, Schwarm's artistic research and the other research conducted by the project were disseminated to the public and used for outreach and teaching. Students have interacted with and continue to use the *1 Kansas Farmer* posters as part of assignments structured to highlight methods of approaching research from an interdisciplinary perspective and to cultivate the students' abilities to interpret various forms of content. Perhaps most encouragingly, instructors report that their students connect the themes of changing water availability and agricultural land use investigated in Kansas to these same issues in the larger world. An environmental studies student provided feedback exemplifying the exhibition's goal that viewers might observe the subject of farming more complexly and empathetically, noting that studying the *1 Kansas Farmer* posters "gives me the impression that farming and living rurally is not an easy way of life, and requires a lot of forethought, yet also the ability to adapt."

Through museum events and presentations, these exhibitions and Schwarm's photographic contributions in particular were used to create new opportunities for engagement between the research-project team members and community stakeholders, be they advisors, policymakers, or farmers. The posters were shared at a Kansas National Science Foundation conference, the annual Governor's Water Conference, a conference for "Women Managing the Farm," a Kansas Chapter of the American Planning Association symposium, and were displayed at Garden City Community College and Scott County Library in Scott City. Schwarm's photographs were also displayed at a subsequent Governor's Water Conference. The Kansas Water Office published some of Schwarm's photographs in one of their annual reports to the governor and legislature. In each instance, the sharing of imagery allowed complex issues concerning

farming to be shared with various audiences. Schwarm's work was praised for its ability to communicate agricultural environments and the farmer's point of view to audiences that might be unfamiliar with these perspectives yet charged to act upon them through policy decisions and other forms of advocacy. The exhibition yielded enthusiastic results from an external advisory board's report concerning the research project, noting, "The dissemination of the project work through the Spencer Museum of Art is truly original and spectacular."

Schwarm's participation in the project affected the work he produced as well as the work of the research team. Schwarm produced thousands of photographs for the project and made nearly a thousand available for online viewing via the website Flickr. When the research team met to observe and discuss his photographs, these opportunities became a way for members to communicate with each other in a new way. The art became a language that researchers from different disciplines could all speak together. Schwarm, in turn, was inspired by these discussions to seek new subjects for his investigations. Many of the photographs of rural communities and an image of a community discussing the possibility of forming a water-management group that are part of this book were taken in response to conversations about the significance of local communities for farmers. Schwarm's photographs amplify the work of the project team, making the focus of a scientific research project a subject that a broader audience can experience and appreciate. Though they were produced within a research framework, the photographs form their own statement about Kansas farmers that is worth showcasing for its own merits.

Schwarm has turned his lens toward the Kansas landscape and its inhabitants with a focus on the way these farmers represent themselves. Schwarm is best known for his color photographs of prairie fires. The new series, *Kansas Farmers,* retains the same geographic focus on Kansas as those prairie-fire images, but draws both stylistic and conceptual inspiration from Schwarm's earlier, formative projects. In 1974, Schwarm, Terry Evans, and project organizer Jim Enyeart traveled the state of Kansas to produce photographs for a project titled *No Mountains in the Way.* This

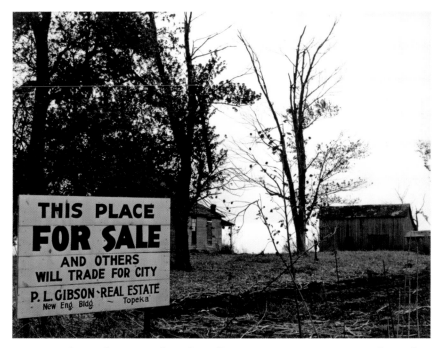

Figure 4. John Vachon, Farm for Sale, Jefferson County Kansas, *1938, gelatin silver print. Spencer Museum of Art, The University of Kansas, Gift of David C. Henry, Class of 1982, 2005.0197.*

Figure 5. Larry Schwarm, Kansas, *1978, gelatin silver print. Spencer Museum of Art, The University of Kansas, Gift of Larry Schwarm, 1978.0097.*

exhibition and catalog emulated the artistic and sociological approach to subject matter that characterized Farm Security Administration (FSA) documentary photographs produced during the Great Depression. One example of FSA photography from the Spencer's collection by John Vachon (fig. 4) demonstrates this visual linkage among the landscape, the farmer, and his or her social and economic concerns. Vachon and other FSA photographers' interdisciplinary approach to subject matter informed *No Mountains in the Way* and remains a relevant influence for *Kansas Farmers.*

For *No Mountains in the Way* and subsequent work from the 1970s (fig. 5), Schwarm focused on the landscape. In those early photographs and in *Kansas Farmers,* Schwarm's pictorial language often emphasizes signs, billboards, and public murals as a way to tease out the process

through which presentation of cultural identity, regulations, or acts of vandalism become representations of people and places. His formal language also complements his subject. Schwarm relies on the stark horizontality of a Kansas skyline, the monotony of monocultures that read as deceptively flat planes of space, and the sparseness of rural populations to tell stories about Kansas and its cultural landscape through pictures. His photographs contain the vernacular qualities of specific characters, places, and practices that reveal the spirit of this region.

Kansas Farmers represents a selection of photographs Schwarm produced for the research project that reflects the core themes of that study, notably farmer land use decisions, climate change, and biofuel prospects, but also showcases Schwarm's own pictorial inquiry concerning farmers and farming today. The photographs are presented here as an autonomous

statement, yet cannot be entirely extricated from their interdisciplinary origins. The many researchers involved in the project, as well as the many human subjects they studied, all possess remarkably diverse training, experience, knowledge, and ways of seeing the world. The land they studied possesses similar geographic, topographic, and visual variety.

To better reflect this diversity, accompanying texts similarly showcase different ways of seeing, reading, or understanding Schwarm's photographs. Each text attempts to augment the diverse ways experts connect these images to their own research and practice, be they parallels to insights gleaned during interviews with farmers, Schwarm's recollections concerning the photographs, or accounts of the ways in which the images relate to climate predictions, land use changes, or groundwater conditions. The photographs, paired with textual commentary, offer a visually compelling narrative that contextualizes the daily lives of farmers, farm communities, and farmlands, and their place in our larger world. Through the interplay of text and image, *Kansas Farmers* explores the realities of farm life, the plethora of factors that can affect decisions farmers make, and ways to illuminate numerous kinds of knowledge and insights about agriculture today and in the future.

Plates

Larry Schwarm created these photographs as part of his contribution to the Biofuels and Climate Change: Farmers' Land Use Decisions research project. The captions were written or in many cases edited or compiled by Kate Meyer based on feedback from project researchers and other experts, most frequently from Schwarm himself. These experts are listed in the acknowledgments section.

Schwarm's photographs communicate information on their own, but they represent just one way of seeing Kansas. The captions provide context and interpretation for each photograph by drawing on a wide variety of information and viewpoints from the different disciplines represented in the project. This pairing of images and captions highlights Schwarm's contribution to an interdisciplinary research project while allowing readers with different kinds of knowledge and expertise to engage with the world of Kansas farmers in new and familiar ways.

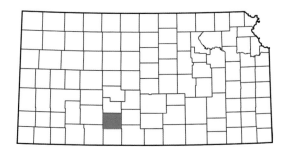

Laurence and Pauline Schwarm in front of their 100-year-old farm, Greensburg, Kansas, June 2011.

Larry Schwarm brings first-hand knowledge to his observations of Kansas farmers. These are his parents, Laurence and Pauline Schwarm. They hold a photograph taken around 1912 of the original house on this property. The farmstead was given to Schwarm's grandfather, John, as a wedding present. The original barn still stands, and the windmill is in the same location. Laurence Schwarm was born in this house, lived in it his entire life, and died here at age ninety-three in April 2017. Laurence and Pauline were married for seventy-four years.

The photograph of a photograph collapses and compresses a century of the Schwarm family's dedication to this farmstead. The historical photograph demonstrates this dedication, with each modification representing an improvement to the farm and each eduring element a tribute to structures built to last. The Schwarms hold their farm and its history in their hands and look out at their son the photographer with soft smiles.

Larry does not experience time on this farm in the same way as his parents. He left Greensburg after high school and became a photographer rather than a farmer. Still, this place tethers him to family, farming, and farmland. The photograph serves as a credential; Schwarm possesses ingrained knowledge of this landscape and the people who derive their livelihood from it.

14

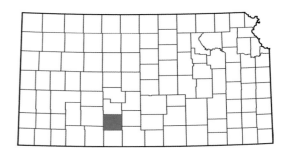

Laurence and Baxter, Kiowa County, Kansas, November 2010.

A farmer, his dog, and his pickup truck might represent the most iconic components of farm life aside from the farm itself. At the age of eighty-six in 2010, Laurence was older than the average fifty-seven-year-old Kansas farmer but representative of this aging population. In Laurence's lifetime, the average age of farmers increased and the average farm size rose as the number of farms and farmers dwindled. This consolidation creates uncertainty for the future of any farm beyond the life of the farmer. Will a farm stay in the family, or will it be leased or sold? To these long-term uncertainties we can add more immediate concerns. Will it rain? How will this year's crop fare? Farmers must make decisions amid many indeterminate variables.

The future may be unknowable, but the path before Laurence is clear. He looks ahead with focus as Baxter gives us a reassuring smile. During the Schwarms' long tenure of dog ownership, when a dog liked to ride in the truck, Laurence referred to it as *his* dog. If it didn't show any interest in riding in the truck, it was *Pauline's* dog. The two companions seem ready for a ride.

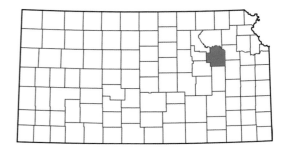

Divided, Wabaunsee County, Kansas, April 2009.

This isolated building in the Flint Hills is unified, but each half represents different building approaches and structural functions. The detailing and craftsmanship on the stonework suggest this structure began as a small limestone house, probably in the late nineteenth century. The limestone was likely quarried nearby. The corrugated steel on the left was likely added in the 1950s or later. The height of the addition's door is at about truck level and indicates that the repurposed building was likely later used to store hay. The building indicates adaptability and resilience leveraged over time.

Imagine the facade is a map of Kansas. The eastern portion of the state was settled first and remains more populous. Kansas entered the Union just prior to the Civil War and has deep-seated cultural regard for sovereignty, independence, and strong centralized government. Communities boomed and sometimes later busted because of varying demand for meat, wheat, and technological innovations such as manufacturing. Eastern Kansas receives more rain while the High Plains/Ogallala Aquifer underlies the more arid, western portion of the state. Nearly 90 percent of Kansas is devoted to farmland, and agriculture drives nearly half of the state's total economy. These common goals and outputs despite differences in settlement, history, and water availability determine much of the laws, culture, and land use practices across the state.

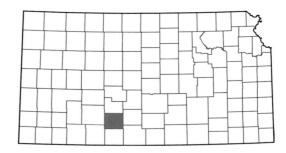

Generations: Filling a stock tank—about six miles south of Greensburg, Kansas, October 2011.

Every generation is expected to be more successful, healthier, and stand taller than the one before. Though not all related to one another, these three generations of farmers watch water filling a stock tank. The water is coming from a well and will water two hundred head of cattle. Farmers at this location have recently set up a new watering system that provides even more water because the well being diverted in this image is 150 feet deep and going dry. The High Plains/Ogallala Aquifer is a vast, ancient underground formation of water-bearing permeable rock containing more than enough water to fill Lake Huron. The aquifer varies in depth below the earth's surface and ranges from a few feet to hundreds of feet in thickness. It underlies parts of South Dakota, Wyoming, Nebraska, Colorado, Kansas, Oklahoma, New Mexico, and Texas. The aquifer cannot be seen with human eyes, yet we see its water in the form of irrigation as well as smaller applications such as this single hose filling a stock tank. In nearly all locales, the aquifer is being depleted at faster rates than the formation can naturally recharge. How will our instinctive drive toward maximizing potential compete with this diminishing resource?

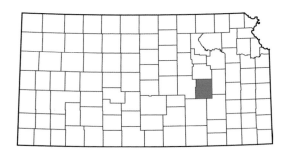

Thunderstorm north of Cassoday, Kansas, April 2009.

Precipitation accounts for the most visible form of water in Kansas. The state experiences an east-west precipitation gradient, receiving as little as an average of sixteen inches of rain annually in the far west and up to forty-five inches per year in the east. Dangers may accompany the beneficial rains of a thunderstorm—wind, hail, tornados, and floods can all damage crops, equipment, and buildings. Precipitation interacts with the soil differently depending on land cover. Native prairie grasses with their deep root systems like those seen in these Flint Hills pastures will absorb this rainfall more slowly with less soil displacement, with runoff filling area ponds and creeks. On cropland, a high-intensity storm may erode the soil and displace nutrients essential for long-term food production. Chemical fertilizers found in storm runoff adversely affect groundwater quality while soil runoff and stream-bank erosion fill eastern Kansas reservoirs with sediment. As scientists project that the frequency of high-energy storms will increase as dry periods between storms lengthen, farmers must contemplate management practices that will increase the resiliency of their land.

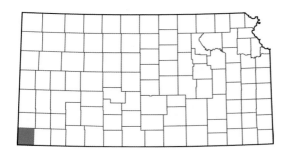

Drought-damaged wheat with storm clouds, just east of Elkhart, Kansas, July 2011.

In 2011 and 2012, drought ravaged the High Plains. Wheat requires twelve to fifteen inches of moisture a year to grow successfully, which is well within the range of annual precipitation received across the state. In 2011, precipitation totals were lower and temperatures were higher than usual. A farmer interviewed for the research project who recalled farming conditions back to the 1980s emphasized the seriousness of these conditions, stating, "This year is the worst I can remember for all crops, all year. . . . This is the worst, 2011."

Prior to this day in July, Elkhart had received about two inches of rain total for the year. The dark blue storm clouds brought nearly another inch of moisture to this sparse, golden field—still too little for this wheat. The crop was so poor the farmer did not bother to cut it.

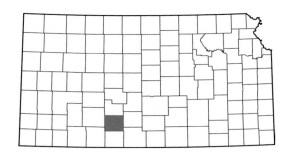

Post office in Belvidere, Kansas, October 2007.

About half of Kansans live in rural areas and small communities. Although some rural communities are growing, many towns are shrinking precitously. These communities face the consolidation or closure of their schools and the loss of other community resources such as local businesses and services. The closure of a post office can be a death blow for these little towns. Residents in depopulated communities must drive significant distances to obtain a gallon of milk or see a doctor.

Belvidere was once a thriving community in the middle of ranch country. Although a few buildings remain, the town's year-round population is zero. It is used as part-time headquarters for a ranch. This postal shelter is for residents that live in outlying areas. Belvidere's post office was discontinued in 1996.

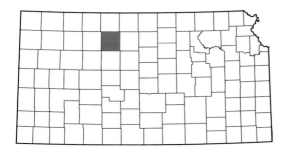

Mural in Palco, Kansas, July 2012.

A public mural can reveal a pictorial expression of communal identity. It also occasionally covers an unnattractive surface with something a little more interesting. This mural evokes an idyllic and romanticized vision of place where managed, manicured, productive lands are bountiful and good. The land supports each kind of use, including growing crops, raising livestock, sustaining wildlife, and harnessing energy without conflict. The mural nearly matches the surrounding blue sky and white clouds, but the grass in the foreground reveals drought conditions that sharply contrast against the mural's bounty. Communities must reconcile their hopes for the land against its variable capacity to meet those expectations.

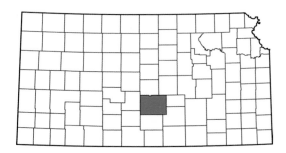

Showing swine at Kansas State Fair, Hutchinson, Kansas, September 2010.

Members of a 4-H Club pledge their *heads* to clearer thinking, their *hearts* to greater loyalty, their *hands* to larger service, and their *health* to better living. The national youth-development program is administered in Kansas by the US Department of Agriculture and K-State Research and Extension. The educational mission of 4-H emphasizes learning by doing. For many particpants, 4-H provides instruction beneficial to a career in farming. Children who raise animals to exhibit at their county fair learn how diet affects the weight of animals being readied for market. Animals must be fed, watered, and exercised daily, actions that all instill personal responsibility in the 4-H'er. Members who qualify in their category can exhibit items they made, collected, or raised at the Kansas State Fair in Hutchinson. At county and state fairs, anyone can walk through the livestock barns and see the pride that people have in their animals.

When you are showing a pig, the goal is to isolate the pig from the others in your group and encourage it to walk before the judge for evaluation. Swine can be trained to walk in certain directions and raise their heads by administering light taps to the animal's sides. Pigs are more difficult to control than cattle and tend to socialize in groups, which promises amusement for the audience and lessons in patience for these young showmen.

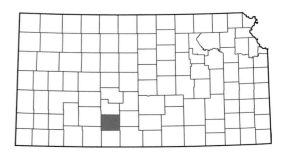

Piles of milo in Greensburg, Kansas, October 2015.

Grain sorghum, more commonly called "milo," most typically consists of red or white varieties. Red is more traditionally grown in the Midwest and is used almost exclusively for livestock feed and ethanol production. White milo is slightly more digestible and is sometimes used for milling sorghum flour. Milo is part of a group of three fall crops that are harvested in nearly the same time frame. Usually corn is first, followed by soybeans, and finally milo. If it is a good harvest, grain elevators often are filled to capacity, so the milo is stored on the ground until it can be transferred. Kansas leads the nation in sorghum production, although it is frequently less profitable than corn or wheat. The non–genetically modified crop requires less water than corn and is gaining popularity in export markets, making it an attractive lower-risk choice for a high-risk environment.

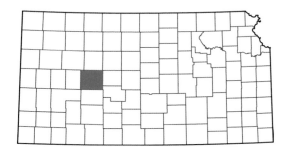

Old farm machinery in field, Ness County, Kansas, May 2012.

Given the orderly placement and organization of these implements, this is likely a salvage yard or collection of bygone farm equipment that has become a mechanical graveyard. The oldest pieces are from the early 1940s, with tractors and self-propelled combines progressing from 1950s models on up. Some machines show signs of recent use, while newer models have clearly outpaced others in the sequence. Although older machinery lacks innovations deemed critical to the scale and capacity of modern, large-scale farm operations, farmers are often loath to get rid of anything that might be useful one day. Farm manufacturers encourage farmers to either buy or want to buy a new model every year to remain competitive in the market. There were probably machines here that were picked, sold, or scrapped over the years. The arid climate in the High Plains is ideal for preservation of iron and steel, allowing a few parked pieces to eventually seem a bit like an agricultural museum display.

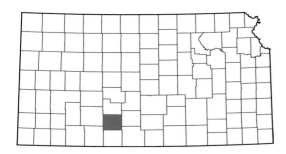

Transferring wheat from hopper to truck, Kiowa County, Kansas, June 2012.

Although a harvest is far from fully automated, part of the work is simply watching the grain flow. When wheat is harvested, a combine cuts and threshes the grain. This grain collects in a tank called a "hopper." When a hopper is full, the wheat is transferred via an auger, as shown. This particular harvest operation utilized at least three combines, two hoppers, and two semitrucks. A minimum of seven people was therefore necessary to operate the equipment. The efficient, machinelike crew harvested this field of about eighty acres in about three hours. The darker field to the left is summer fallow wheat; the remnants from last year's crop were left alone to rest the soil. Despite the drought conditions throughout much of 2011 and 2012, this farm is far enough east that the wheat yield was lower than in some years but still acceptable. Later in the season in the same area, dryland crops, or crops grown without added irrigation, suffered severely.

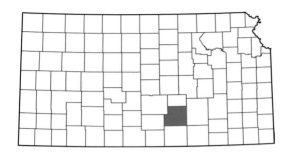

Grain prices, Cheney, Kansas, June 2012.

A farmer is the biggest gambler in the world. Scarcity drives supply, and prices are highest when a farmer probably has the least chance to successfully produce. Weather forecasts, yield predictions, comparison to the rest of the global market, and time until harvest all drive the price for a given commodity. When conditions are good and a farmer feels the satisfaction of creating an abundance, the profits are generally slimmest. Farmers must decide when to sell their grain, speculating that any costs incurred by waiting will be offset by obtaining a better price. Agricultural commodity prices pertinent to Kansas farmers are set by a board of trade or mercantile exchange headquartered in Kansas City or Chicago.

During the 2012 drought, farmers in the eastern parts of the state were less affected, so Cheney farmers had some wheat to sell at this good price of $7.07 per bushel. Irrigators would have had higher profits, even accounting for the higher input costs. Crops that were planted later than wheat, such as corn, soybeans, and milo, were all more directly affected by the drought conditions and had poor returns across the state.

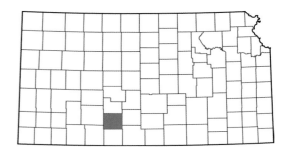

GPS-operated tractor on Gamble Farms north of Greensburg, Kansas, April 2012.

When surveying Kansas farmers, researchers observed that 21 percent of respondents utilize precision agriculture such as this example of a tractor with GPS capability. The choice of equipment largely depends on the scale of the farm. Newer technologies provide competitive advantages but also represent significant investments that may or may not be offset by improved profit. This tractor can drive in a straight line with nominal deviation and corner cleanly but still depends on the vision of an operator to notice obstacles or anomalies. No fuel is wasted from a crooked row, seeds are planted at perfect intervals, and fertilizers can be applied with minute precision. These automations allow the operator to multitask: make phone calls, check irrigation systems via smartphone, or calculate prospective yields or expenditures. In the air-conditioned cab of the largely automated tractor, technology separates the farmer from the farmland. The land becomes more of a commodity, a medium for chemicals and seeds to produce a product.

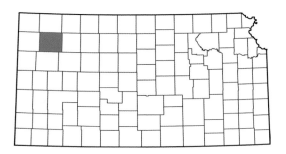

Wheat stubble about three miles west of Colby, Kansas, 2012.

In one-point perspective, orthogonal lines converge at a single vanishing point. These wheat rows impose two-point perspective on our view, as rows seem to recede to two points in the distance. Crops are planted in parallel rows to maximize efficiency and to improve convenience. Rows are typically straight unless the farmer decides to plow according to the land's contour. In rows, each plant receives more light without casting shadows on its neighbors and can be accessed through the interrows for weeding, treatments, and harvesting. This field is double-seeded, essentially planted with twice as much wheat as recommended—an inefficiency that overtaxes resources. The atypical rows indicate that this wheat was not planted with precision equipment.

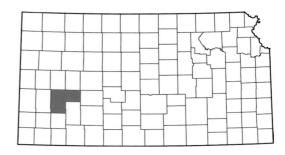

Brookover Ranch Feed Yard with EAT BEEF—KEEP SLIM *sign, May 2012.*

Beef cattle deemed ready for slaughter to provide prime cuts are called "fat cattle." These cattle represent a portion of a vast food web. The size of this facility, plus the size of the granaries below the "EAT BEEF—KEEP SLIM" sign, indicates a dependency upon significant quantities of corn and other crops to feed these cattle. This demand benefits area growers, farm- and irrigation-equipment vendors, and crop consultants. All of these relationships ultimately rely on massive quantities of water extracted from the declining aquifer that underlies this region. A great deal depends upon this seemingly invisible resource, which affects everything we observe in this image.

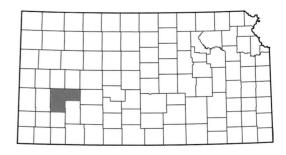

Weighting tarp with old tires, Brookover Ranch Feed Yard, May 2012.

Six men stand in a human chain over a sloping mound of vegetation partially covered with a tarp and by tires they toss to one another. They are weighing down a tarp that covers a trench silo. These silos are usually cut out of a hillside, but in a flat area they can be built aboveground. The men are creating silage for the thousands of cattle that are fed and finished at this commercial cattle feedyard. This silage is made from grain and green roughage produced from triticale (a cross between wheat and rye) and sorghum. The mixture is compressed and covered so it will ferment. The silage is part of the feed mixture used at Brookover and can keep for several years. Filling, covering, and, later, uncovering the silo is tremendously hard work. Finding laborers to complete these tasks in rural, depopulated communities can be challenging. This labor shortage represents one reason populations in southwestern Kansas have become increasingly ethnically diverse.

In Kansas, so-called ag-gag laws prevent photographic documentation of animal facilities without permission from the owner. Ag-gag laws are divisive but ultimately speak to the physical separation that exists between agricultural facilities and the public's lack of knowledge concerning what takes place at these facilities. Schwarm gained unlimited access to Brookover through familial connections. He was happy to find that conditions were more humane up close than they appeared from a distance and that animals were treated with respect, making the visit a very positive experience.

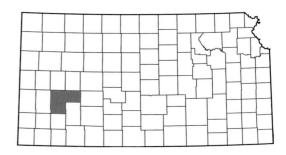

Feed truck, Brookover Ranch Feed Yard, May 2012.

Feeding time! Space recedes into the distance along the perspectival line of the feed bunk as a feed truck zooms closer to us on the left and head after head of cattle approach from the right and begin to eat. At Brookover, cattle are fed twice a day and given constant access to hay and water. As cattle mature, the content of their feed is altered to encourage weight gain. Cattle arrive at the feedyard in groups and remain with that group through the process of putting on weight for finishing. On average, cattle arrive when they are between five hundred and seven hundred pounds and will be ready for shipment at around thirteen hundred to fourteen hundred pounds. Brookover strives for the animals to gain approximately three and a half pounds per day. Each head spends approximately 180 days at the feedyard. The feed, cattle, and conditions are carefully monitored to ensure maximum cattle performance. It takes twenty-two to twenty-four months to rear, finish, and ready most cattle for slaughter. This feedyard is positioned near five major meatpacking facilities. Brookover grows most of its own roughage and purchases grain from other farmers. In southwest Kansas, grains such as corn and sorghum are irrigation-dependent. The success of the cattle industry in this region is inexorably linked to the vitality of the High Plains/Ogallala Aquifer.

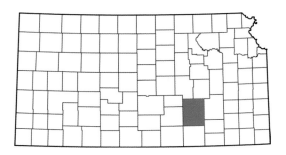

Wind turbine and windmill, south of Beaumont, Kansas, June 2012.

The small windmill at the center of this image represents technology dating back over a century. On the High Plains and throughout much of Kansas, windmills were used to draw groundwater from wells and supply water necessary to sustain domestic use, irrigate a few acres, and water some livestock. Today's wind turbines tower over the windmills of yesterday. Modern wind farms use enormous turbine blades to capture energy from wind power. Kansas is currently fifth in the nation in terms of wind-power capacity, enough to supply power to 1.5 million homes. This ranking comes despite considerable controversy surrounding the desire to prohibit wind production in the Flint Hills, a region known for its wind as well as its few remaining vestiges of the tallgrass prairie.

Renewable energy like wind power has infrastructural costs and poses concerns for prairie ecosystems and bird populations, but represents tentative yet significant steps toward an energy future not dominated by fossil-fuel carbon extraction. Wind also represents a new opportunity for farmers who receive significant payments by leasing their land to energy companies. Schwarm spoke to a man who now "grows" turbines as well as crops on his farm. He jokingly proclaimed that he finally has a forest.

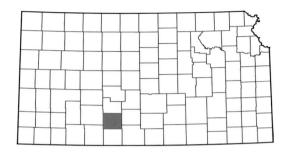

ECOLOGICAL BASTARDS—redneck bumper sticker, Kiowa County, Kansas, May 2012.

This bumper sticker was likely first produced during the 1970s energy crisis when the United States faced a petroleum shortage, and American environmental regulations helped increase domestic reliance on high-priced foreign oil. This driver therefore likely prioritizes individual liberty and unfettered economic opportunity over government regulation intended to protect natural resources. When leveraging these personal freedoms against environmental sustainability, farmers believe that farm practices should protect the long-term capacity of the land, even if this means lower production and profits. They do not, however, see federal environmental legislation as good arbiters of those practices. Although farmers may not find all environmental regulations fair, they are quite willing to profit from them. In 2012, Kansans received over $100 million for their participation in the Conservation Reserve Program, wherein farmers are paid to take their croplands out of production and convert them to vegetative cover.

53

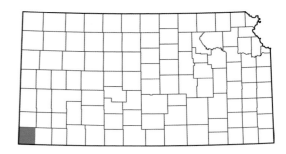

Cattle in drought-damaged pasture near Elkhart, Kansas, July 2011.

In the southwest corner of the state, once the epicenter of the Dust Bowl in the 1930s, high temperatures and sparse rainfall echo conditions of the past. In 2011, Elkhart received only ten inches of rain, but this arid region receives only eighteen inches in a typical year. This parched landscape cannot sustain the cattle pastured here. The few, wispy clouds offer little assurance that relief is coming. Farmers and ranchers provide water in troughs shown in the foreground. Water is at the literal and metaphorical forefront of this landscape. The life and health of the land depends upon this scarce resource. The native grasses are completely dormant because of the aridity, offering no sustenance for grazing. Farmers must supply all of the hay, feed, and supplements necessary to support these animals. Unsurprisingly, farmers were forced to purchase these commodities from other parts of the country during the drought, and many were forced to sell their livestock.

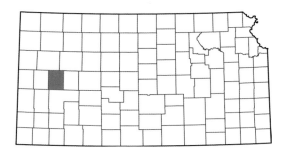

KANSAS FARMER sign with rain gauge, east of Shallow Water, Kansas, July 2012.

Although a rain gauge is less useful to a farmer than a soil-moisture meter, farmers pay very close attention to weather while acknowledging its fickleness. During an interview conducted for the research project, one farmer admitted, "You know, you just operate day-to-day. Weather is the weather. It develops, it does what it does, and you just hang on for the ride." One poorly timed thunderstorm could wreck a harvest in a day, while a seasonal hot spell will slowly destroy a crop. Droughts interspersed with extreme rainfall events have already been observed more frequently and are predicted to become even more likely in the future. Farmers likely cannot sustain these and other anticipated changes in their world without assistance, a reliance that conflicts with the farmer's desire for autonomy.

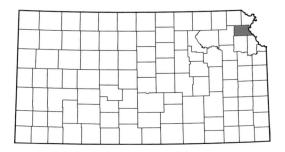

Marvin in his field of new terraces, Atchison County, Kansas, May 2012.

Atchison County is in the far northeast corner of the state, where there are more hills and vegetation and fields tend to be much smaller than in the west. The drought was just beginning to show itself in this part of the state, and Marvin was concerned that there might not be enough moisture in his freshly terraced field to plant. Terracing means grading fields into even terraces with channels and ridges. These terraces serve two related functions: to keep runoff from eroding the soil, and to retain some of that precipitation so it has more time to soak in. Marvin had only recently plowed the field, and the dirt clods had not received rain to break them down for a planting bed. A planted seed also needs moisture to sprout, which this field lacked. Although his decisions are intended to reduce erosion and help crop growth long-term, at the moment captured in this photograph the land is intensely vulnerable and prospects are uncertain.

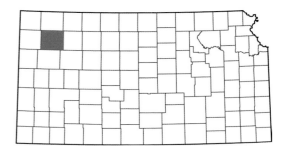

Morning work conference, Lon Frahm Farm, Colby, Kansas, July 2012.

Lon Frahm, sixth-generation farmer and Frahm Farmland's chief executive officer, stresses that he is a businessman, and his business is farming. Other employees drive tractors and work in the fields while Frahm spends much of his day at the downtown office in Colby. At the morning meeting, team members check the status of their automated irrigation systems. At any moment, their technology can reveal the location of every piece of precision equipment on the farm, who is operating it, its fuel status, field conditions, and the moisture status of their grain bins.

Members of this farm crew include a chief financial officer, a crop-production manager, mechanics, machinists, electricians, and an agronomist. Each member of the team makes informed recommendations about crop choices, treatments, and production timing. Frahm Farmland consists of nearly twenty-seven thousand acres (about forty-two square miles) and counting. The business grows both dryland and irrigated crops. About a third of the acreage is irrigated.

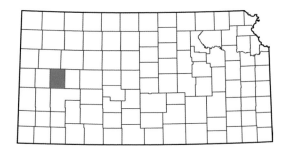

Empty train cars in wheat field near Friend, Kansas, May 2012.

A blue sky and golden wheatfield bisected by a receding line of train cars dramatically reveal the immense scale of farming in the plains. The unincorporated community of Friend is about twenty miles north of Garden City. These empty train cars are part of the Garden City Western Railway, which travels north–south connecting Garden City to Scott City, interchanging with the much larger BNSF Railway. The railroad primarily transports agricultural commodies such as grain, fertilizer, and farm implements. This photograph was taken on May 24, just about two weeks prior to typical harvest time in western Kansas. Faint traces of green can still be glimpsed in the ripening wheat. The train cars await the impending harvest.

63

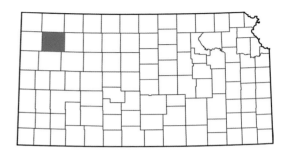

Irrigated corn, Thomas County, Kansas, July 2012.

This stark composition featuring a stripe of irrigated corn along the horizon was photographed at the K-State Northwest Research–Extension Center near Colby. In this instance, irrigation is supplied in a straight line across the field. In the foreground, the nonirrigated soil appears to have been tilled but is also bare. With soil conservation practices such as no-till (farming without disturbing the soil to produce new crops amidst the plant residue of the prior seasons) and cover crops fairly widespread, bare fields like this one are atypical. Practices that maintain soil cover support soil health even as they necessitate inputs that are detrimental to soil health, such as the application of herbicides. Availability of water can be the primary factor determining these land use practices in western Kansas. Irrigation technology in the semiarid High Plains is moving toward greater efficiency as profit margins tighten and water costs rise. Evaporation and runoff are the enemy, both signs of wasted application. Precision technologies are being developed to give farmers better control over irrigation timing and quantity. Aquifer depletion drives growers, manufacturers, and researchers to learn how to use less water while minimizing economic impact. By choice or by necessity, changes will occur that affect irrigation-water usage, perhaps resulting in decisions that attempt to sustain the aquifer as well as support the farmers who dwell here.

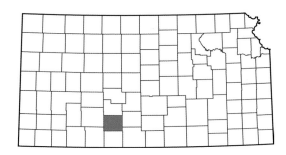

Armadillo and quail in window, Kiowa County, Kansas, August 2011.

Landscapes can be physical, geographic places just as they can be pictures of places. Humans make both kinds of landscapes, not just by the act of seeing them or creating them as art, but also through the ways we subtly and dramatically alter the earth itself. Schwarm utilizes the window to compositionally frame a picture that shows the viewer almost nothing. The flat, unceasing landscape offers few picturesque comforts to improve the aesthetics of our view, save for the rays of sunlight beating down upon the farmland. The complete transformation of former prairies to farm land dominated by monocultures can be seen as a near total conquest of wilderness. This is nature, tamed. Inside the air-conditioned home we cannot perceive the heat of August. Our picture of the unnatural, natural landscape is completed by the addition of wildlife in the form of taxidermied quail and an upturned armadillo. The armadillo is an invasive species that migrates north into Kansas as we experience warmer winters, creating conditions more hospitable for this creature. The landscape, though stationary, reflects many choices and changes.

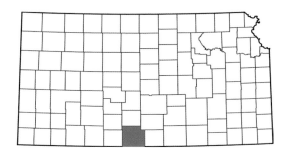

Post office, Hazelton, Kansas, August 2014.

As most rural Kansas communities are farm communities, farmers represent important stakeholders for the future of these towns. When farmers speak of improvements they would like to see in their small communities, many note the beneficial impact of an ATM or a convenience store that might stock a few groceries. They mourn the loss of local businesses, facilities, and services. During an interview conducted for the research project, one farmer noted that, with these changes, social bonds also decline. He stated, "It's not like it used to be, you know, several years ago. Farmers helped each other. Not anymore. It's everybody for himself." For the roughly one hundred residents in Hazelton, schools, gasoline, groceries, and hospital services are all eight to twenty-two miles away. None of the buildings on this block are in use.

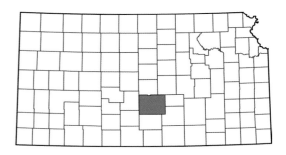

Custom Mills Feed Store near Arlington, Kansas, 2012.

A feed store is a grocery store and pharmacy for farm animals. Feed stores sell food for horses, beef and dairy cattle, baby chicks, and often offer additional supplies used on the farm. Like a pharmacy, a feed store also sells vaccines and antibiotics. These specialty feeds, vitamins, supplements, and medicines allow farmers to obtain desired results for weight gain, dairy performance, egg production, and general health from their livestock.

In the midst of feed supplies for many different kinds of animals, a farmer and a taxidermied longhorn appear to regard each other. Perhaps each is surprised to see a familiar face at the store.

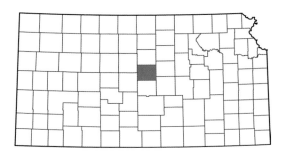

Supper break during wheat harvest, southeast of Wilson, Kansas, June 2011.

A crew of four men and two women work together to bring in the wheat harvest on the Pancake family's farm in Ellsworth County. The workers are related—two brothers, a sister, two cousins, and a wife. The newest equipment used on this farm was manufactured in the 1980s. The farm has been in the family for many decades. This crew lives in surrounding communities and maintains other jobs but shares in farming duties. Greg brings a cooler of food out to his cohorts in the field for a short supper break. The trucks and even the rows of wheat stubble cast long shadows. The family will go back to work before darkness falls.

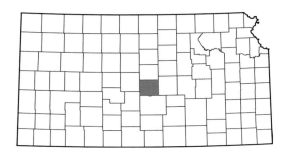

Aerial spraying, Rice County, Kansas, June 2013.

Aerial application continues to be a thriving business. A monoculture crop like corn is inherently vulnerable to weeds and pests despite efforts to genetically modify plants with built-in resistance. This plane might be spraying a herbicide that these young stalks can tolerate. The corn is approaching its rapid-growth stage and is starting to devlop its primary root system. A herbicide would curtail any weeds competing with the corn to give it more advantage. Alternatively, the spray could be a pesticide if prior scouting detected an infestation, or a fungicide if the field is recovering from hail damage. The spray could also be fertilizer or some micronutrient concoction intended to keep the crop in good health.

Regardless, the objective for adding a chemical to the system is the same: the farmer wants the crop to thrive, which will increase the chances for a bountiful harvest. All of these applications come at a cost, of course, and each time the farmer must weigh the expense against the potential benefit. Spray drift represents yet another risk as the chemical that benefits this field may be harmful to the plants, humans, or animals nearby. With the uncertainties in what the yield will be and what the crop will be worth, rarely are these decisions without risk, even with the widely used safety net provided by federal crop insurance.

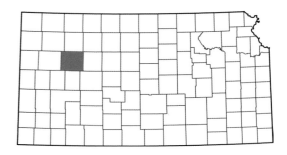

Interior of Western Plains Energy Ethanol Plant near Oakley, Kansas, July 2012.

This interior view of an ethanol plant reveals a new decision for farmers: to plant for food or fuel. Currently, most biofuels are produced from crops such as corn or grain sorghum. With time and innovation, scientists may find ways to make economically competitive cellulosic ethanol from sources such as grasses or even algae without consuming fossil fuels in the process. At present, farmers can obtain more profit from crops like corn thanks to ethanol subsidies, but the decision to change to a different land use strategy depends upon factors such as the compatibility, the risk, the ease, and the advantage of the change relative to current practices and current benefits.

At this ethanol plant, one bushel of grain yields three gallons of ethanol. The plant runs on corn and milo. It processes approximately eighteen million bushels of grain and produces approximately fifty million gallons of fuel per year.

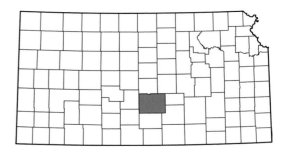

Poultry auction in Yoder, Kansas, March 2012.

Yoder is an Amish settlement of roughly two hundred residents near Hutchinson that benefits from tourism highlighting the community's heritage. Religion can play an important but less explored role in farming traditions and decisions. Anabaptist groups, such as the Amish and the Mennonites, often restrict the use of modern conveniences such as electricity as part of their religious beliefs. In Yoder, farmers are comparatively progressive and use tractors for plowing and disking, largely to reduce the burden on their draft animals in the summer heat. The farms are small, and crops are grown to feed local livestock.

The Yoder Poultry Auction and Fowl Sale is held the last Friday of every month. The attendees are a mixture of Amish locals, other members of the community, and visitors. There are no restrictions on who can sell or buy, and the atmosphere is very warm and friendly.

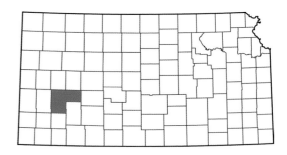

ATV tracks on Arkansas River bed, south of Holcomb, Kansas, February 2012.

From its headwaters in Colorado, the Arkansas River flows through Garden City, Dodge City, Great Bend, Hutchinson, and Wichita before passing through Oklahoma and Arkansas and finally joining the Mississippi River. The river is claimed for recreational and municipal use, and its water is heavily used for irrigation. This high degree of extraction has caused the water table in western Kansas near the Arkansas River to decline dramatically. The river rarely flows through southwest Kansas now. Thousands of years of flowing water have left behind a deep bed of sand in the Arkansas River's banks. During heavy rains the river still flows, clearing out brush and debris and leaving a winding sandy roadbed, an ideal spot to hot-rod an ATV. Rivers are pathways for water, fish, and wildlife. During the drought, the river is still a pathway, albeit for a different kind of wildlife.

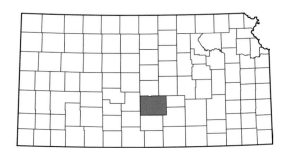

Irrigating wheat in Reno County, Kansas, April 2012.

In 1945, Kansas adopted a doctrine of prior appropriation, meaning that, if you had the earliest claim to surface or groundwater on file with the state, that water right was yours to use as authorized. Until recently, if you did not use your water right, you could lose it. This right establishes Kansas's water as an article of commerce that can be bought and sold for economic gain. The appropriation doctrine was intended to facilitate the orderly exploitation of the resource, not conserve it. As the supply has dwindled, tension between irrigators, environmentalists, litigators, and other consumers has grown.

Although groundwater extraction is monitored and limited both by law and by the production capacity of individual wells, this management is insufficient to maintain aquifer water levels. Despite future precipitation forecasts that are estimated to be similar to the present, temperature is projected to increase. Increased temperatures correspondingly increase evapotranspiration, the combination of evaporation and plant transpiration from the land surface to the atmosphere. Somewhat ironically, yet again, the more we use water, the more we lose it.

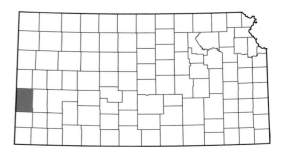

Main Street, Syracuse, Kansas, June 2013.

At sixteen miles from the Colorado border and just north of the Arkansas River, the future site of Syracuse, Kansas, was once part of the Mountain Route of the Santa Fe Trail. By the 1870s, Syracuse was a stop on the Santa Fe Railroad. The town's wide Main Street is indicative of typical frontier towns designed to accommodate the turning width of a team of horses.

Today, the approximately eighteen hundred residents of Syracuse can enjoy a historic theater, bowling alley, public swimming pool, and golf course, in addition to the benefits of a local school system, churches, and businesses. The town promotes economic opportunities connected to industrialized agriculture, including farming, feedlots, and dairies. The community-event board posted in the middle of Main Street is updated regularly.

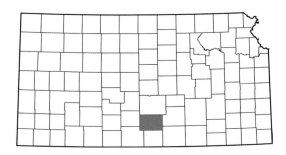

Preparing seedbed, near Cunningham, Kansas, October 2011.

Contour plowing is a soil-conservation practice that was developed in the 1930s to combat erosion. By tilling across the slope of terrain rather than plowing in straight lines parallel to a field's boundaries regardless of slope, less soil and water are lost to runoff. The solitary farmer and tractor shown working this landscape reveal that, while many people and many factors affect a farmer's decisions, in the end, the farmer is the primary actor creating changes on the land. Although this form of plowing represents an industrialized form of agriculture, it is older technology. Innovations such as no-till or low-till farming, techniques that avoid disturbing the soil by growing new crops amid the plant residue of prior seasons or amidst a cover crop, as well as developments in precision agriculture, are newer practices gaining appeal among farmers.

A solitary tractor and a single cottonwood tree provide the only interruptions to this sweeping, undulating landscape that has likely been farmed in the same way for the past few years. Cottonwoods thrive near streams and other groundwater sources. This cottonwood's success may serve as a benediction for the wheat seeds soon to be planted in this field.

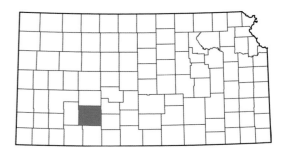

Alfalfa field, Ford County, Kansas, June 2014.

Dried rows of alfalfa hay radiate outward over a gently sloping landscape. This crop is almost certainly watered by center-pivot irrigation. Although the entirety of the circle cannot be seen from this vantage point, the regularity of the harvest pattern and its nonconformity to the contours of the terrain suggest this view represents a portion of a large, circular field. We can also presume this is an irrigated crop due to its location. Ford County is fairly arid, typically necessitating irrigation to grow a water-intensive crop like alfalfa. Alfalfa hay serves as a major food source for the livestock critical to the meatpacking industry in this region. Kansas farmers harvested over two million tons of alfalfa hay in 2014.

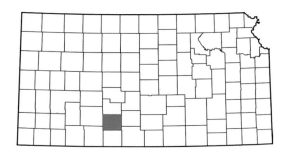

Corn tunnel, Kiowa County, Kansas, August 2016.

"I'm just as corny as Kansas in August!" proclaims a character in the 1949 musical *South Pacific.* In 1949, Kansas harvested 2.3 million acres of corn, yielding 64 million bushels. In 2016, Kansas harvested 4.9 million acres of corn, yielding 699 million bushels. Although twice the amount of the state's cropland is currently devoted to wheat, the corn market is more lucrative. Corn grows rapidly and requires a tremendous quantity of water, fertilizers, and herbicides to thrive. The crop depletes the soil so much that farmers typically rotate their plantings with a nitrogen-fixing alternative such as soybeans. Most corn is used for livestock feed and subsidized ethanol production.

Corn is planted in the spring and, by July and August, sweet corn ears are ready for harvesting. Because most of the corn grown in Kansas is feed corn, when fall approaches, the moisture content of these kernels will decrease, and the ears and stalks will dry before they are harvested around October. As corn stalks grow, they form a canopy that serves as a natural weed suppressant by limiting the amount of sunlight reaching the ground. This shade will also help limit evaporation of soil moisture and keep the ground cooler, which is essential when the frequent stresses of summer heat and drought can take a heavy toll on crops.

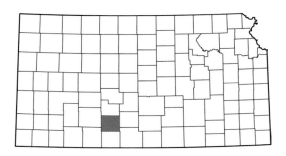

Unloading wheat in Haviland, Kansas, elevator, May 2012.

Trucks of freshly harvested wheat are driven to the local grain elevator. At the elevator, the truck is weighed with a full load. The grain is checked for moisture content, foreign debris, and test weight. Much depends upon the moisture content of the wheat, as 13 to 14 percent is most desirable by the elevator for storage and preservation needs, and the elevator will charge to dry received grain if necessary. From there, the truck pulls into a passage under the silos to unload the grain. We call these silos "elevators" because they generally lift this unloaded grain vertically into an overhead system that redirects the grain into various storage bins. The truck drives back onto the scales to record its empty weight. The difference reveals the quantity of bushels that were on the truck. The elevator in Haviland has a storage capacity of over 1.5 million bushels. This elevator is part of a cooperative that links elevators in other south-central Kansas towns to railroad networks.

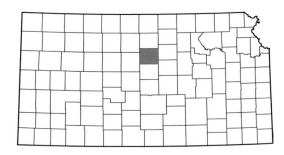

City Hall, Sylvan Grove, Kansas, July 2012.

Despite its comparatively low population, Kansas has one of the highest quantities of local government districts in America. These districts face numerous challenges as they strive to meet the changing needs of their constituents. Today, Sylvan Grove's population is a little over half of what it was a century ago. It was named for twin groves near the townsite, indicating that forestation was something of a rarity for this portion of the state in the late nineteenth century. Sylvan Grove's city hall was originally a garage that housed auto-repair services and farm-implement retail. The public library has also been headquartered in this building since 1956. The consolidation speaks to the community's adaptability to successfully provide these services for its nearly three hundred residents.

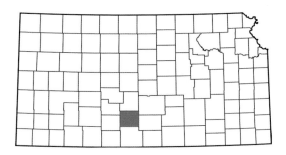

Field of cotton north of Cullison, Kansas, November 2016.

Cotton is generally thought of as a southern crop but is gaining popularity, particularly in south-central Kansas, because it needs considerably less water than corn and offers some diversity to crops that might be affected by other elements. It is planted at about the same time as corn, milo, and soybeans, but takes longer to fully mature. Harvest is often in late fall or early winter. Although Kansas cotton production is fairly negligible compared to other crops, if water becomes less available it may become an increasingly compelling choice for farmers.

Cotton is planted in rows, and the plants stay small for a long period of time. Once growth really takes off, the plants become bushy and lose some of the tidiness we expect in more traditional row crops. The plant has a delicate flower, which develops a hard, green boll that generally breaks open around the first frost date. When the bolls open, the fields turn white and by then the foliage has mostly turned brown.

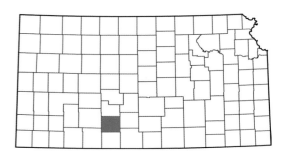

Country Café, Mullinville, Kansas, October 2012.

In Edward Hopper's iconic painting *Nighthawks* from 1942, we look across a darkened city street through the window of a diner to see a few people sitting at a counter. In this photograph, we sit on the opposite side of a looking-glass vision of Hopper's world. The darker café interior seems to be empty, and we look out the window to the sun-drenched pumps of a gas station. Both worlds seem lonely, though one is urban and the other rural.

The Country Café enjoys patronage from truckers and other travelers along US Route 54 and the local community alike. Mullinville church-goers frequently dine here as a group on Wednesday evenings. Daily pie offerings may include apple, cherry, chocolate, coconut cream, and Oreo cream. Popular entrées are the chicken-fried steak or a cheeseburger.

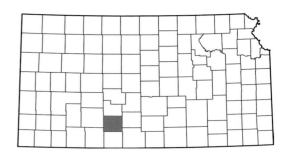

Ki Gamble planting corn north of Greensburg, Kansas, April 2012.

At Gamble Farms, Ki Gamble, his wife and the farm's business manager Kimberly, and their son Kasey grow wheat, corn, soybeans, and milo in addition to raising cattle. Their farm consists of over twenty-five thousand acres, which include dryland and irrigated cropland. The Gambles regularly rotate crops, not planting the same thing in the same land in consecutive years. They also rotate dryland fields out of production and let them sit fallow every several years. Kasey concentrates more on their cattle operation. Ki is a workaholic, averaging four hours of sleep a night during busy seasons. He has been known to shut off his tractor at 2:00 to 3:00 in the morning and sleep on the ground so he can wake up and be back at work in minutes. His wife brings meals to the field so he does not have to stop. Once he wanted to catch a short nap, so he laid down in one of his irrigated cornfields, figuring the system would spray water to wake him in about an hour. For some reason, the system shut down and he slept for hours. No one could find him in the middle of the cornfield. Ki would be hard to miss in this future cornfield as his tractor seeds corn in rows. The residue of previous crops remains partially visible.

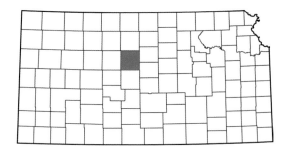

Corner of Main and Harvest Streets, Lucas, Kansas, July 2012.

In Kansas towns, farming is often linked with the identity and fate of the community. Lucas's grain elevator connects its Main Street to harvest both literally and figuratively, as a branch of Great Plains Manufacturing that produces agricultural implements is just down Harvest Street from this location, and both streets connect the town to the state highway. The soaring grain elevator is often the tallest structure in a town, and is itself a product of innovation. As communities began to need larger storage facilities for their harvested grain, new technology offered solutions in the form of concrete cylinders. The vertical cylinders are created with a casting form that is pulled upward as the freshly poured concrete cures. Concrete also serves as the primary building material for the feature that gives Lucas its unique standing as a typical agricultural community but also a vital center for grassroots art in America, S. P. Dinsmoor's Garden of Eden.

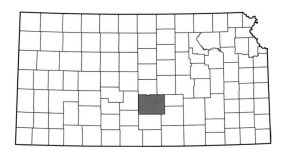

Mom and daughter walking down Main Street, Pretty Prairie, Kansas, May 2012.

The health of rural communities can be linked to their surroundings. Pretty Prairie received its name in the nineteenth century based both on the country's beauty and suitability as prospective farmland. The process of breaking that prairie and converting it to farmland has produced results that are far from pretty. Pretty Prairie's water supply is contaminated because of agricultural pollution, primarily through runoff from fertilizers. The town's water has exceeded nitrate-contamination levels recommended by the Environmental Protection Agency for several years, and Pretty Prairie has distributed bottled water to at-risk citizens to maintain compliance with the law. In 2017, the town agreed to a settlement in order to treat and store their water. This decision will improve Pretty Prairie's water quality but also represents a significant financial burden for its citizens.

Pretty Prairie's population is 715, and about 12 percent of its townspeople work in jobs related to agriculture. On this day, a family walks along the main street of town on their way to the post office. No cars impede their journey.

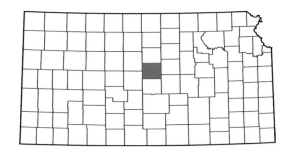

Combines and oil wells, Ellsworth County, Kansas, June 2011.

This farmer waits for a combine in the far distance to finish harvesting a portion of this wheat field so he can unload the grain. The view toward the setting sun includes commodities extracted from above and below the soil. Farmers make money off their land any way they can. In addition to farming the topsoil for crops, farmers may lease their mineral rights to an oil company for significant rates per acre and receive royalty payments for a percentage of the oil produced there. Between 2007 and 2014, rising oil prices and increased drilling caused growth in oil production in Kansas. More recently, prices have fallen and the production from newer wells has waned.

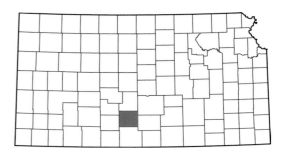

Grain silos at sunset, north of Cullison, Kansas, November 2010.

Schwarm recalls photographing these silos in 1974 when they were brand-new. In the ensuing forty years, farming practices around these silos have changed. The surrounding land has been planted in cotton over the past few years, a crop virtually unheard-of in Kansas in the 1970s. The silos were hit by a tornado in 2007. The condition of the silos, combined with the shift in crop choice, suggests that they may not currently be in use. Despite the immense scale of the grain elevators, from our vantage point the strangely vulnerable structures look like crushed pop cans.

The silos are captured at a fleeting moment as the brilliant red of the setting sun dips below the horizon, sending a crimson flare up each cylinder. At the end of a long, hard day, the final silo seems to sigh wearily, resting its head on the shoulder of a stalwart neighbor.

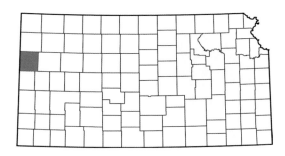

LEMA meeting, Sharon Springs, Kansas, June 2013.

Since 2012, Kansas groundwater management districts may initiate public hearings to implement locally developed, voluntary conservation plans for their specific regions. Once authorized, a district becomes a Local Enhanced Management Area, or LEMA. Although the notion to collectively agree to ration water consumption was met with initial skepticism in many districts, the first official LEMA established in Sheridan County has been deemed a success. This LEMA agreed to strive toward a 20 percent reduction in pumping, yet achieved a 35 percent reduction between 2013 and 2017. The water levels there were dropping about two feet per year and are now declining at only about five inches per year without creating significant financial consequences for irrigators.

Here in Wallace County, about an hour west of Sheridan County, these irrigators are exploring the possibility of forming a LEMA. Concerns relate to issues of representation and trust: Will large-scale farmers have more say than smaller ones? Will restrictions be scaled equally or equitably? The farmers watch a presentation attentively, leveraging their present livelihoods against the long-term sustainability of a diminishing resource.

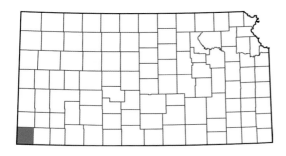

YOU KNOW—painted on metal building in Elkhart, Kansas, 2011.

The rules of entropy seem not to apply to this rusty metal building, as its metal panels begin to resemble the rows and strips of crops that can be found in its vicinity. Inscribed upon the worn walls are the words "YOU KNOW," an act of vandalism with uncertain meaning. The message may be meant for only one person, yet on some level it is likely understood by the larger community. Life on the High Plains can feel vast, with endless vistas in every direction, but when everyone in your community knows your business, it can also feel small. The benefits of a close-knit community with shared history and traditions compete with risks of communal scrutiny and social ostracism. As outsiders, we can observe closely and ask questions as we attempt to understand people and places, to try to know them. Can we really know?

Acknowledgments

Members of the research team and their disciplines are as follows:

Dietrich Earnhart, Economics (Principal Investigator)

Joseph Aistrup, Political Science

Jason Bergtold, Agricultural Economics

J. Christopher Brown, Geography

Nathaniel Brunsell, Geography

Marcelus Caldas, Geography

Chris Crandall, Psychology

Kyle Douglas-Mankin, Ecology

Stephen Egbert, Geography

Johannes Feddema, Geography

Jane Gibson, Anthropology

Eric Hanley, Sociology

Nathan Hendricks, Agricultural Economics

Laszlo Kulcsar, Sociology, Anthropology, and Social Work

David Mechem, Geography

Kate Meyer, Art History

Joane Nagel, Sociology

Jeffrey Peterson, Agricultural Economics

Larry Schwarm, Visual Arts

Belinda Sturm, Environmental Engineering

Stacey Swearingen White, Environmental Planning

The Biofuels and Climate Change: Farmers' Land Use Decisions project acknowledges funding from the National Science Foundation Grant No. 787-316, Award No. EPS-0903806, and matching support from the State of Kansas through the Kansas Board of Regents.

The authors would also like to thank the following individuals for their assistance in this project: Nancy Kassebaum Baker, Peg Bicker, Rebecca Blocksome, Kristin Bowman-James, Ty Brookover, Ali Brox, Rex Buchanan, Doug Byers, Kevin Dobbs, Patrick Dooley, Louise Ehmke, Alexis Fekete, Lon Frahm, Ki and Kim Gamble, Russell Graves, Benjamin J. Gray, Joe Harkins, Tera Lee Hedrick, Robert Hickerson, Elizabeth Kanost, Jude Kastens, Gina Kauffman, Mark Landau, Chuck Meyer, John Miller, Dana Peterson, Emily Ryan, Laurence and Pauline Schwarm, Todd Stewart, Paul Stock, Susan Stover, Jennifer Talbott, Tristan Telander, Xan Wedel, Travis Weller, Lindsey Witthaus Yaserer, and Alyce Zadalis.